# How to Draw
# Hands & Feet
## In Simple Steps

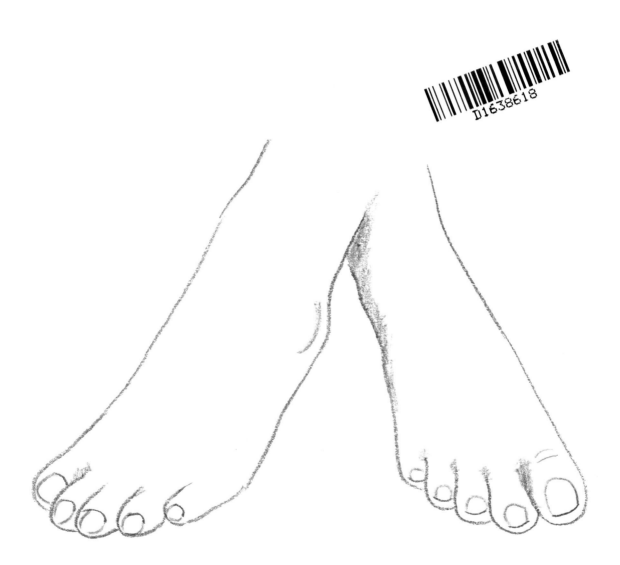

First published in Great Britain 2017

Search Press Limited
Wellwood, North Farm Road,
Tunbridge Wells, Kent TN2 3DR

Text copyright © Susie Hodge 2017

Design and illustrations copyright © Search Press Ltd. 2017

ISBN: 978-1-78221-341-3

Printed in Malaysia

## Dedication

*For Katie and Jonathan – and all the creative hands that turn these pages...*

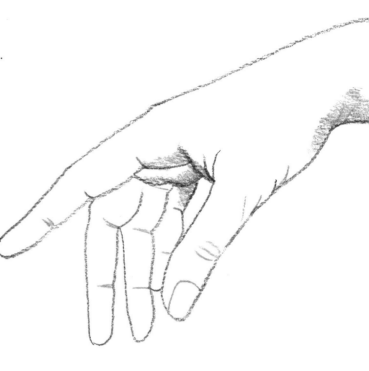

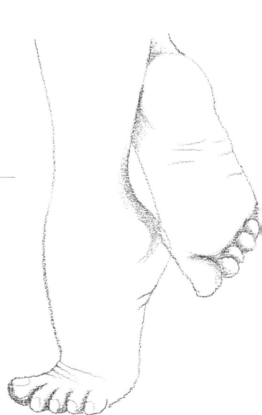

## Illustrations

# How to Draw
# Hands & Feet
## In Simple Steps
## Susie Hodge

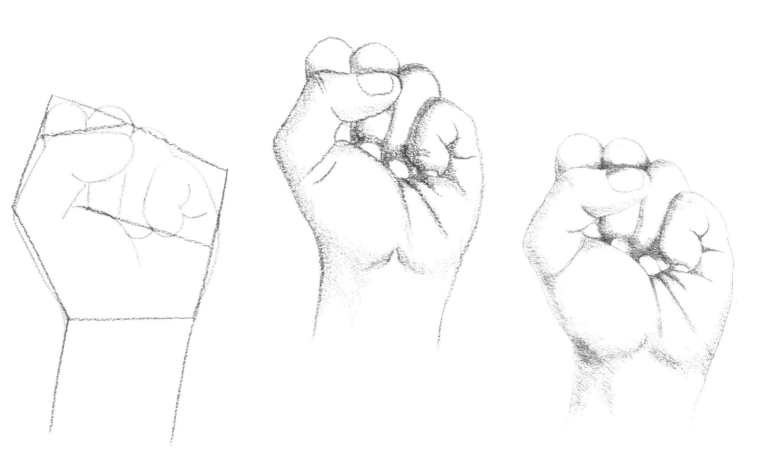

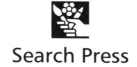

Search Press

# Introduction

Welcome to a book full of hands and feet! Hands that are clapping, clasping, praying, waving and flexing, and feet that are pointing, dancing, walking, running and flexing; all shown through simple step-by-steps, starting from the most basic shapes and finishing with detailed drawings. The book will hopefully take away any concerns you may have and will show you that, like anything, hands and feet really are just simple shapes and all you need to do is to get their proportions right; the rest will follow. If you follow the stages shown here, you will soon master the easy construction techniques and create your own convincing drawings.

The aim of this book is to demystify the drawing process and to show that everything is simply a collection of shapes, lines and proportions. When an image is broken down like this, the process becomes easier than you might have thought. Before you begin, try not to think about the finished image, but draw each stage carefully, concentrating on the proportions and angles – how long is that line? What part of the larger shape is it attached to?

In this book, two colours are used to make the sequences easier for you to follow, so you can see what has already been drawn and what is new. They are in coloured pencils, but it will probably be easier for you to use a pencil – make it fairly soft, such as a B or 2B, and don't press too hard. In the first stages, the drawings are in ochre, marking the basic outlines of the hands or feet. In the next stage, those first lines become blue and all new lines are in ochre – this time softening the outline shapes and marking in further outlines of the hands or feet. In the next step, details start to be added in, including creases, folds and some early tonal marks – again these new elements are in ochre, the previous in blue. Finally, in ochre, remaining details and tones are added. With your pencil, draw the steps lightly and erase any previous guidelines after each one is finished. Take your time and make sure you have drawn the correct proportions and angles before you move on to the next step. In this book, after the four coloured step by steps, each picture of the hands or feet is finished in pencil to show you what yours might look like. Don't press hard, it all needs a light touch, and you don't need to draw every line – include only general, overall indications, such as a few creases or the darkest tones. The final image on each page is the same as the fifth only in watercolour, just to show you another option of what you can do. Use whatever materials you like, but if you are using watercolour keep your water clean and your brushes damp, not too wet.

The simple sequences in this book are intended to make your drawings more accurate and the process less daunting, so I hope you try drawing them all. Each presents a different challenge. Once you are used to the process, try drawing some of your own, from life or from photographs, using the same method. Don't worry about mistakes, they happen to everyone. Either erase them or work through them – don't give up!

If you follow the visual instructions in this book, you will soon feel more confident about your drawing skills and you will develop your own natural style.

I hope that you will be delighted with your achievements.

*Happy drawing!*

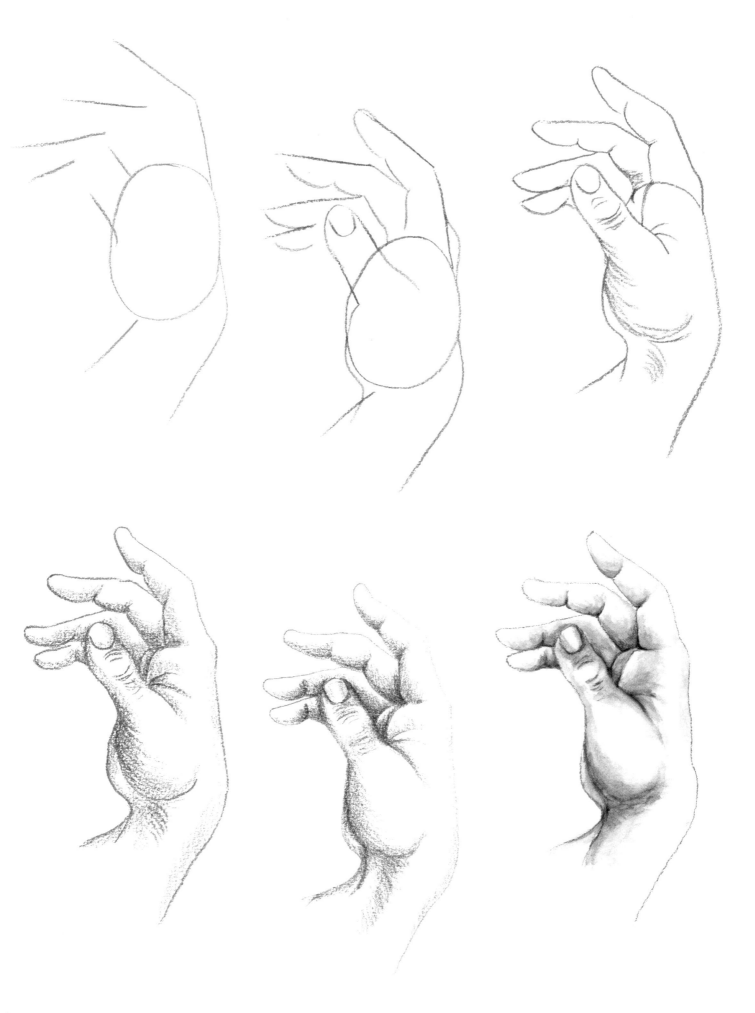

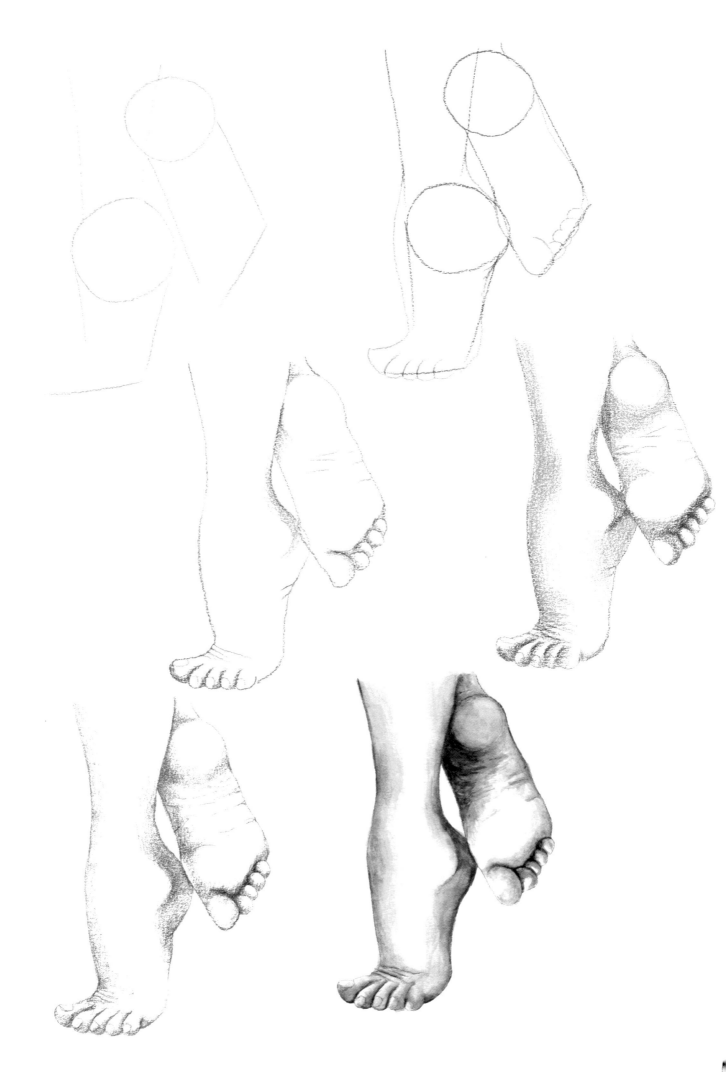

6

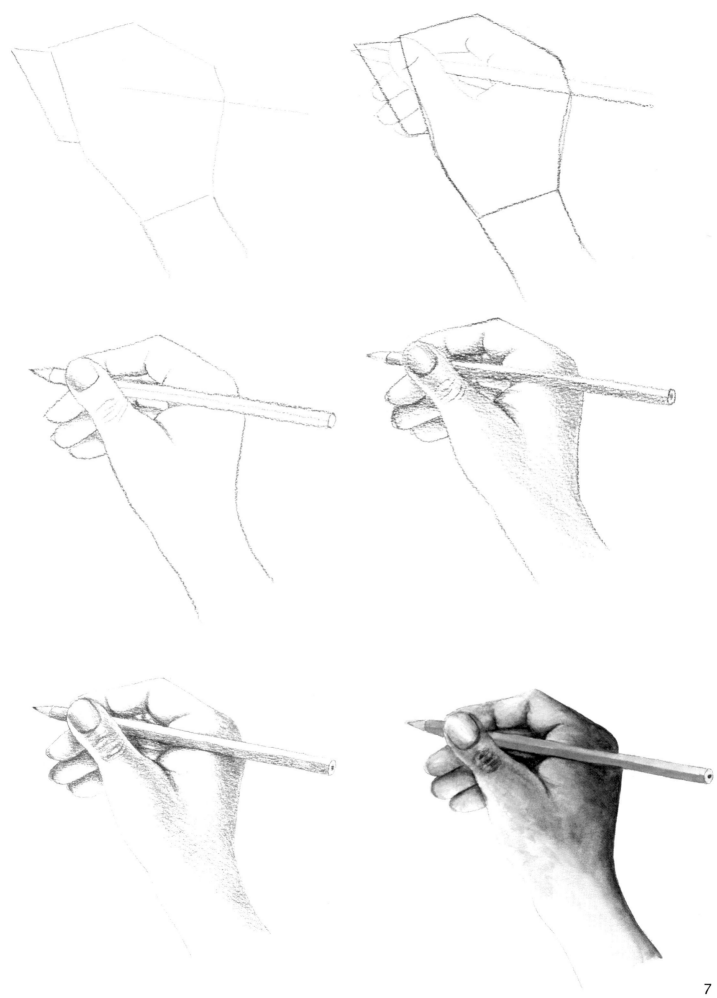

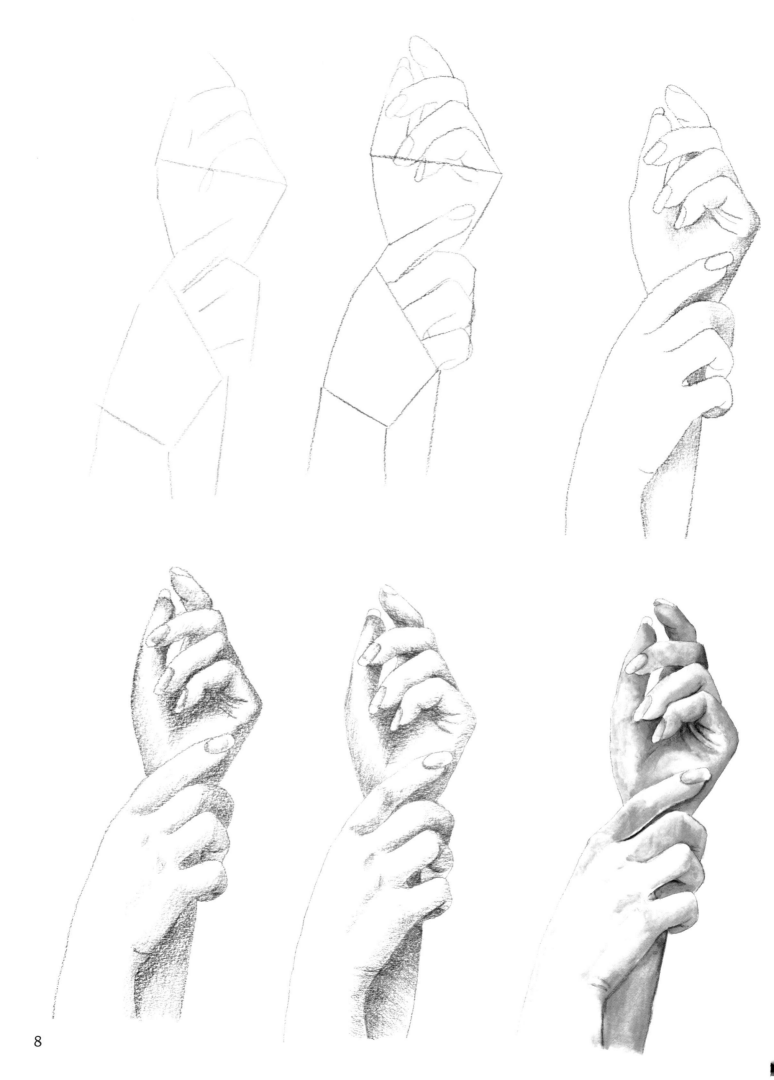

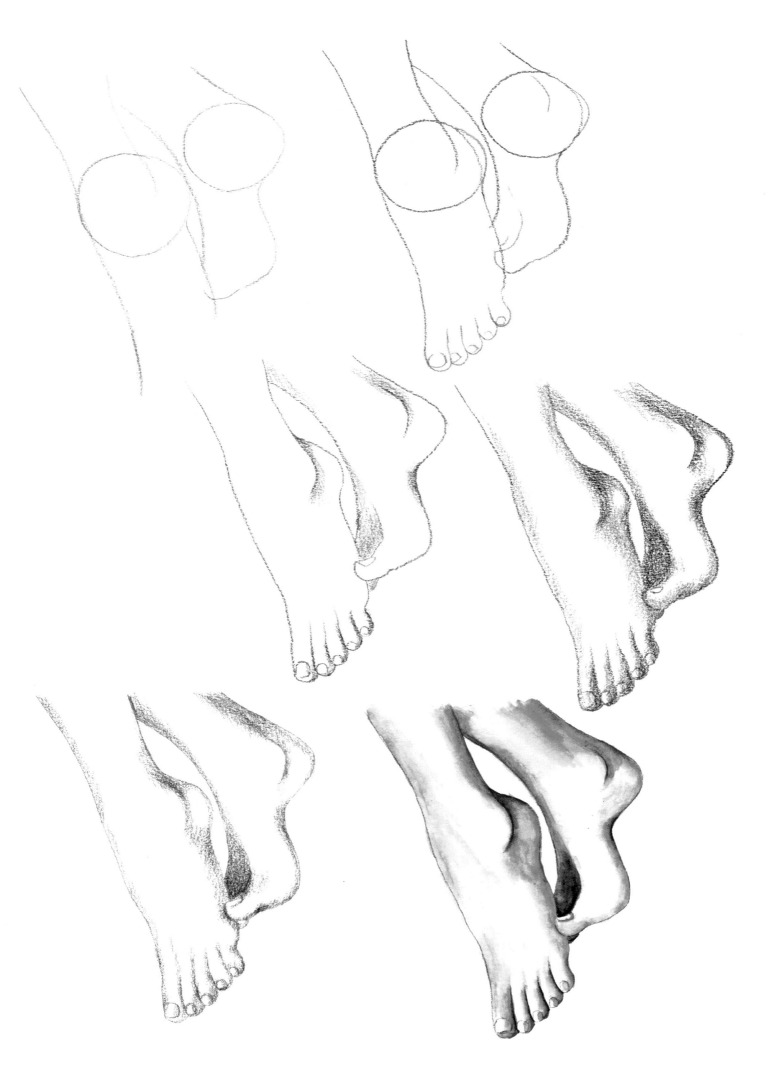

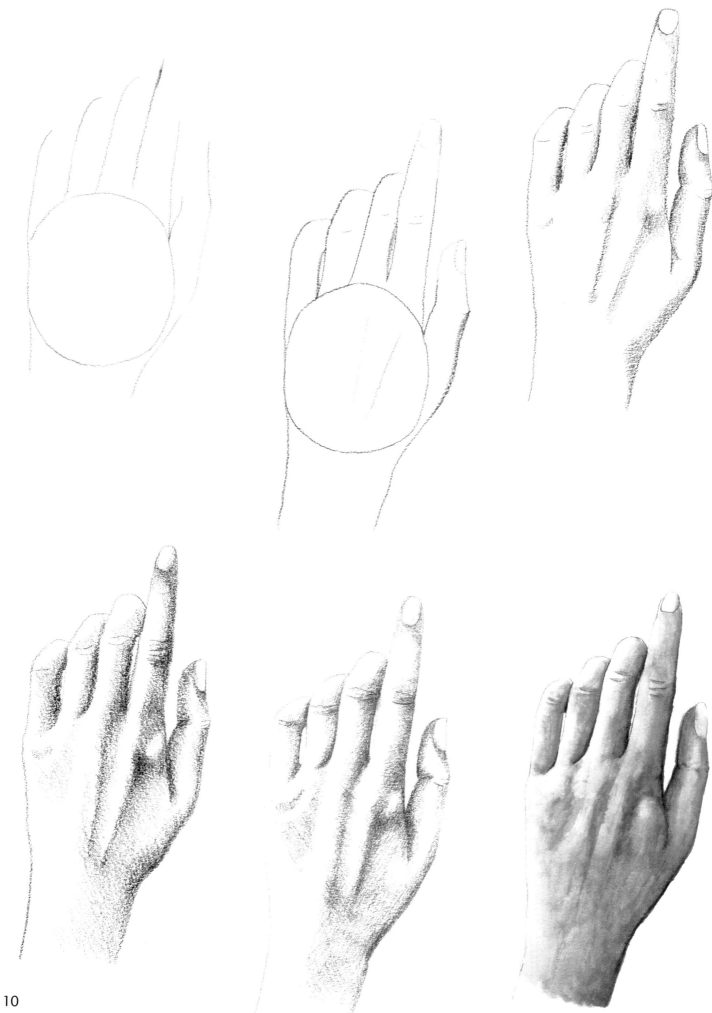

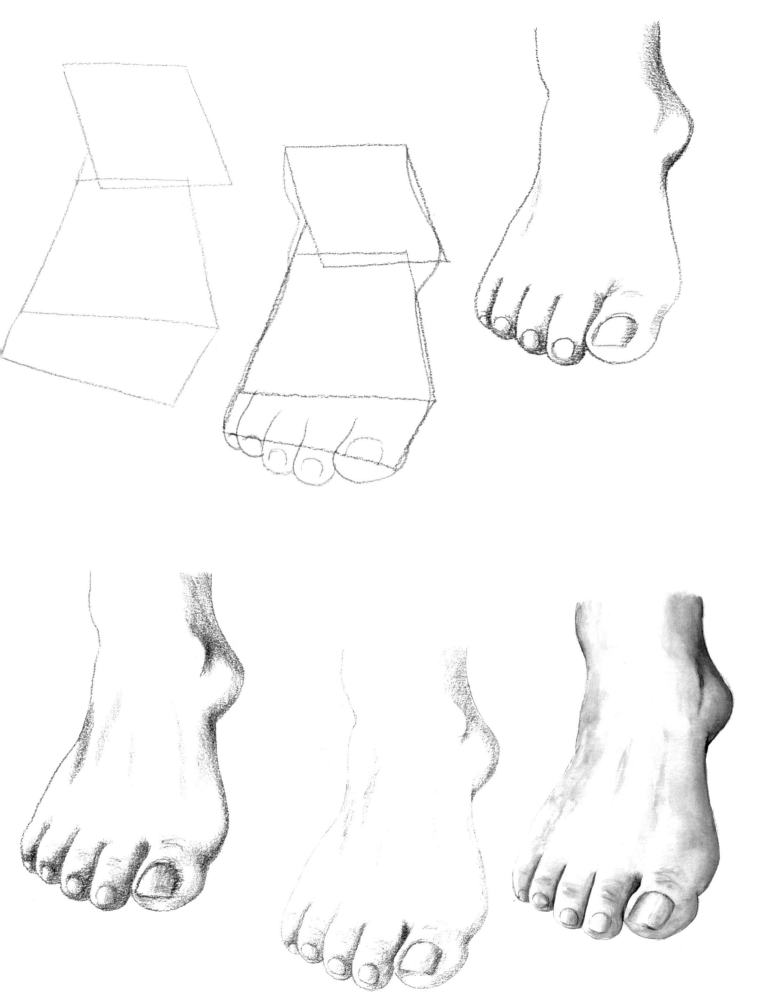

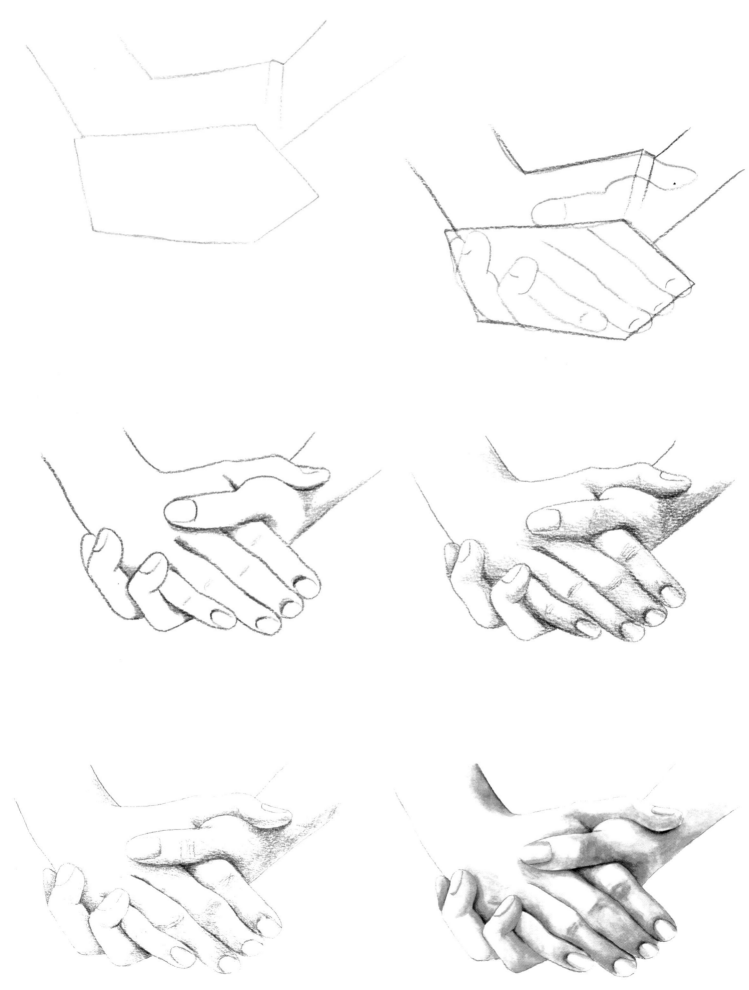

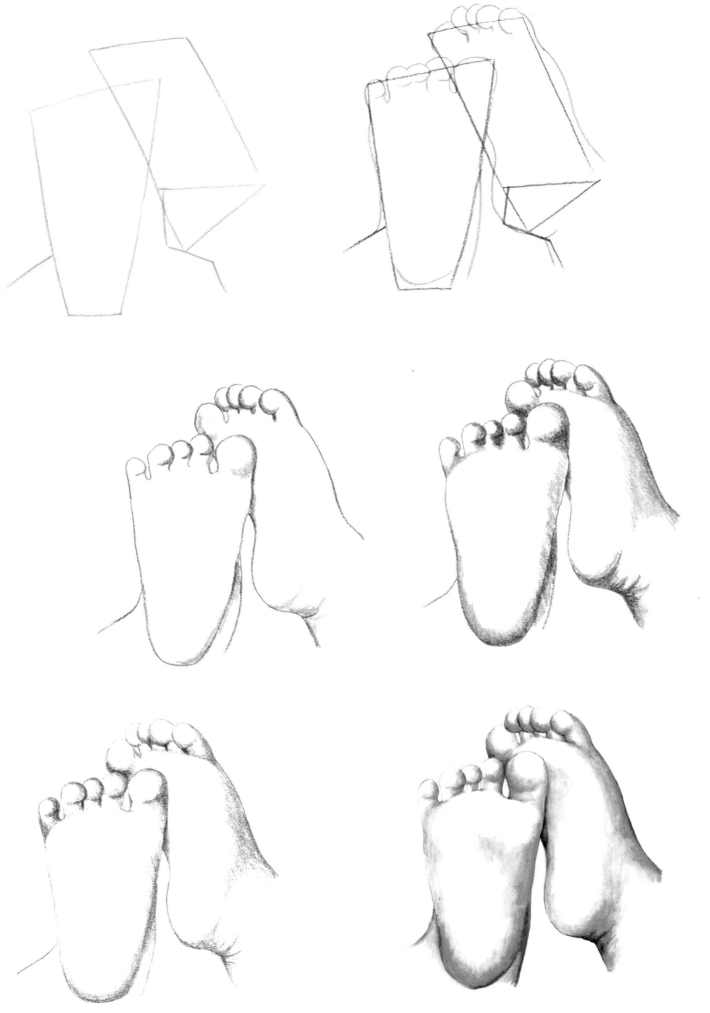

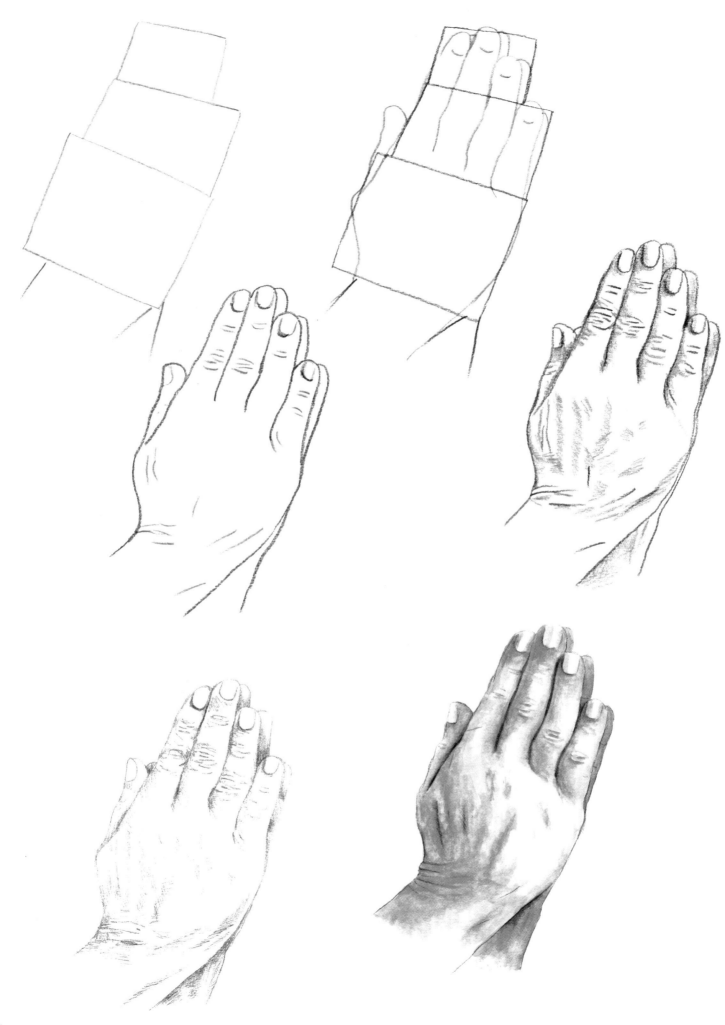

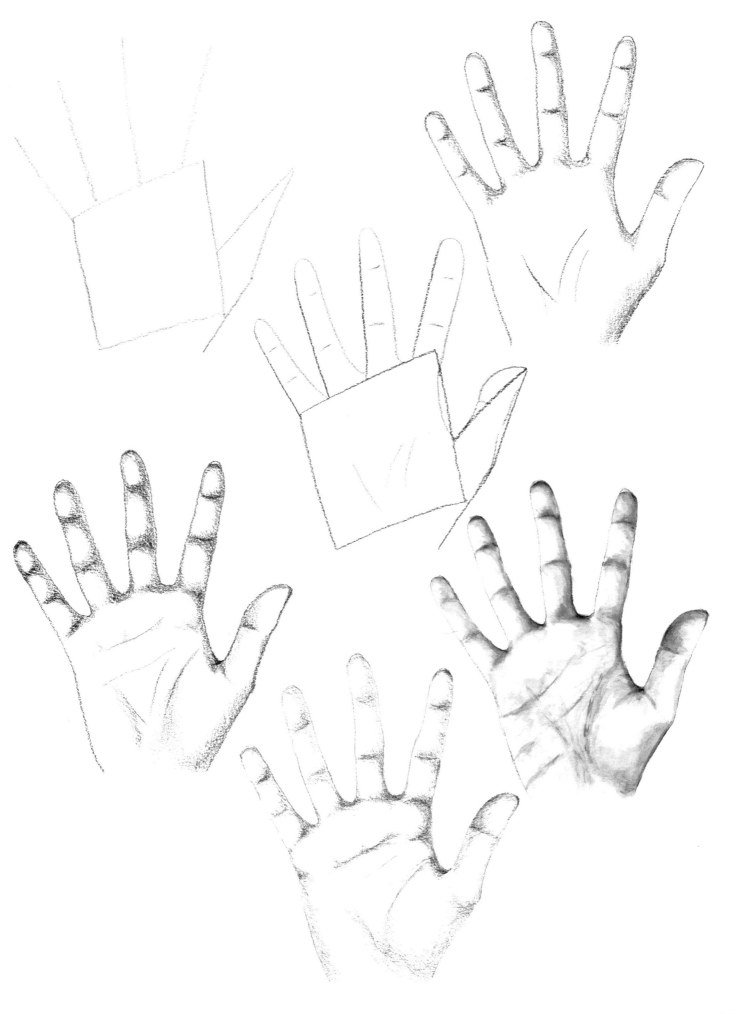

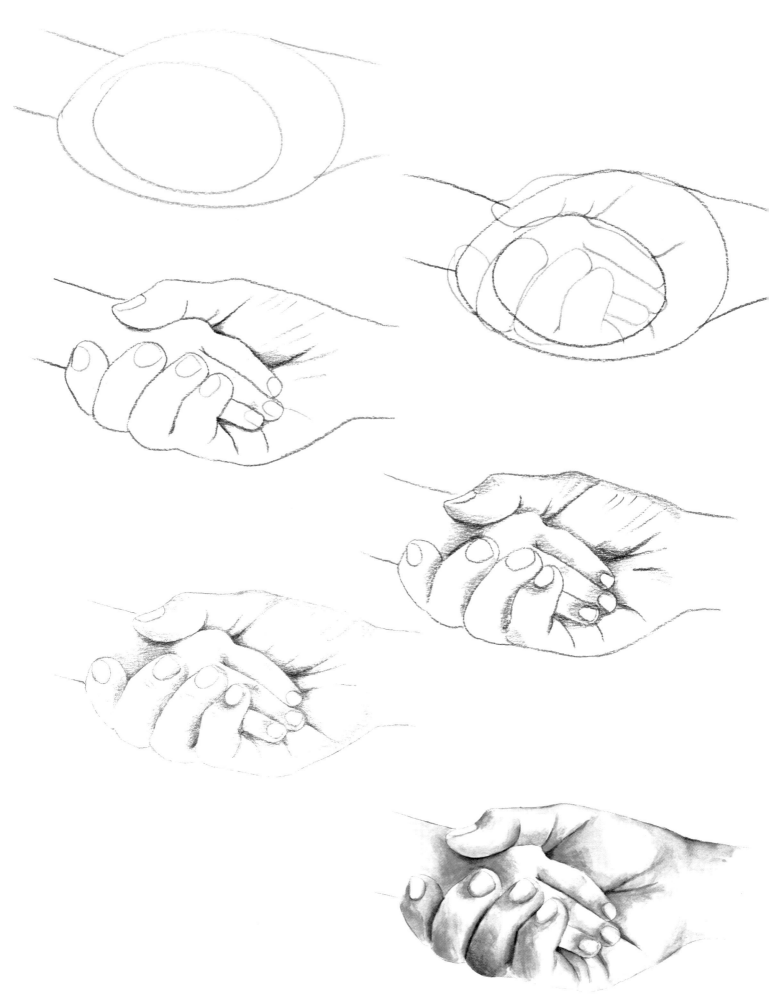

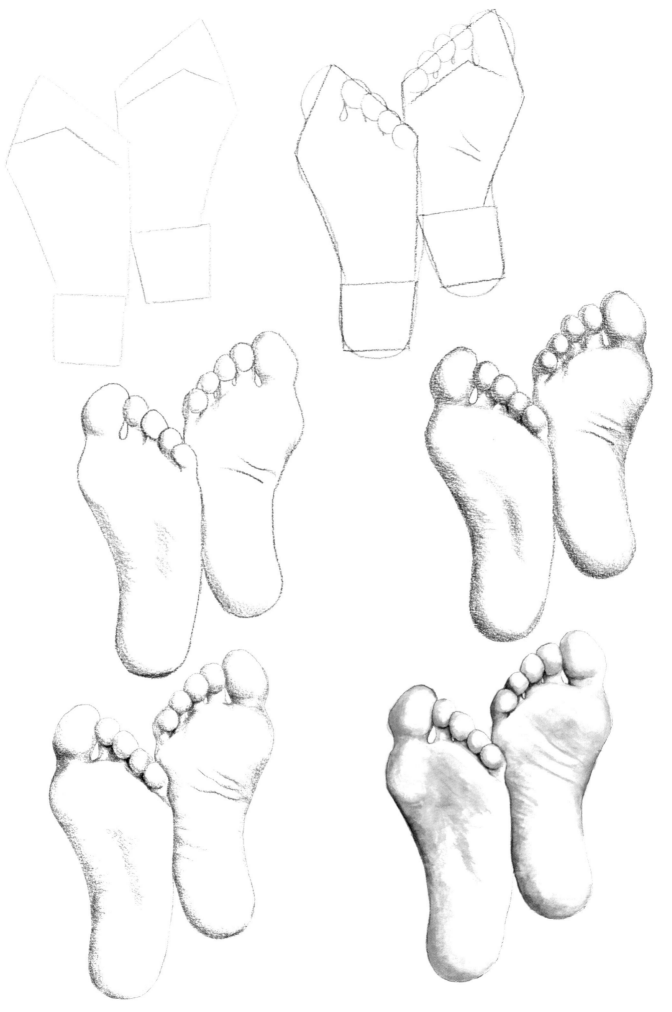

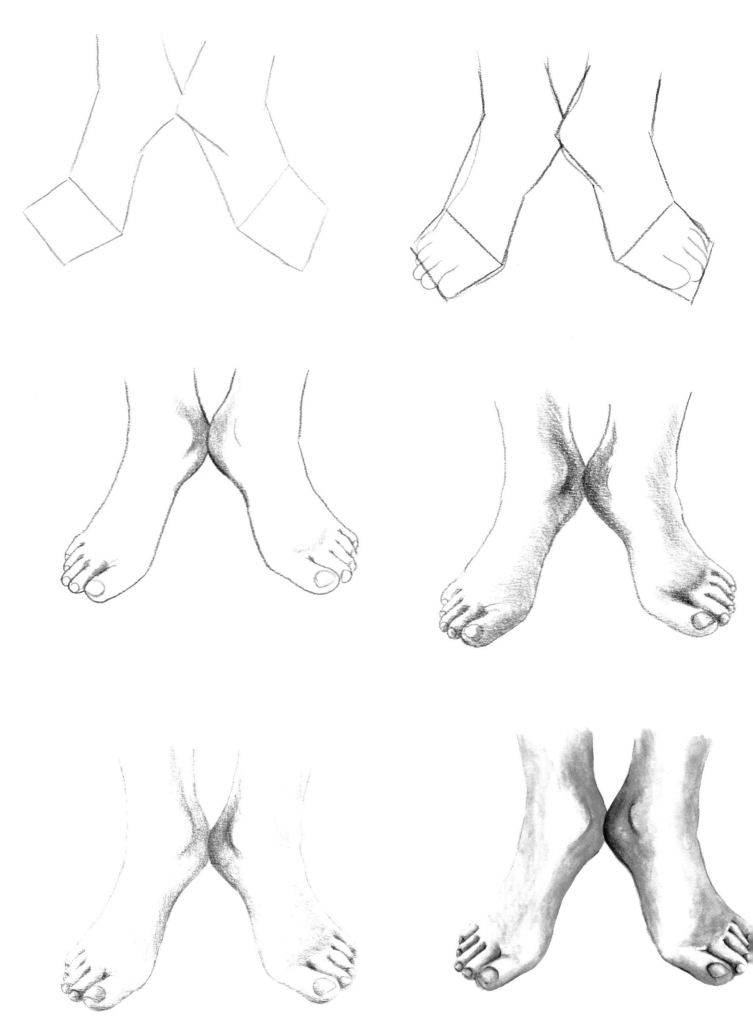

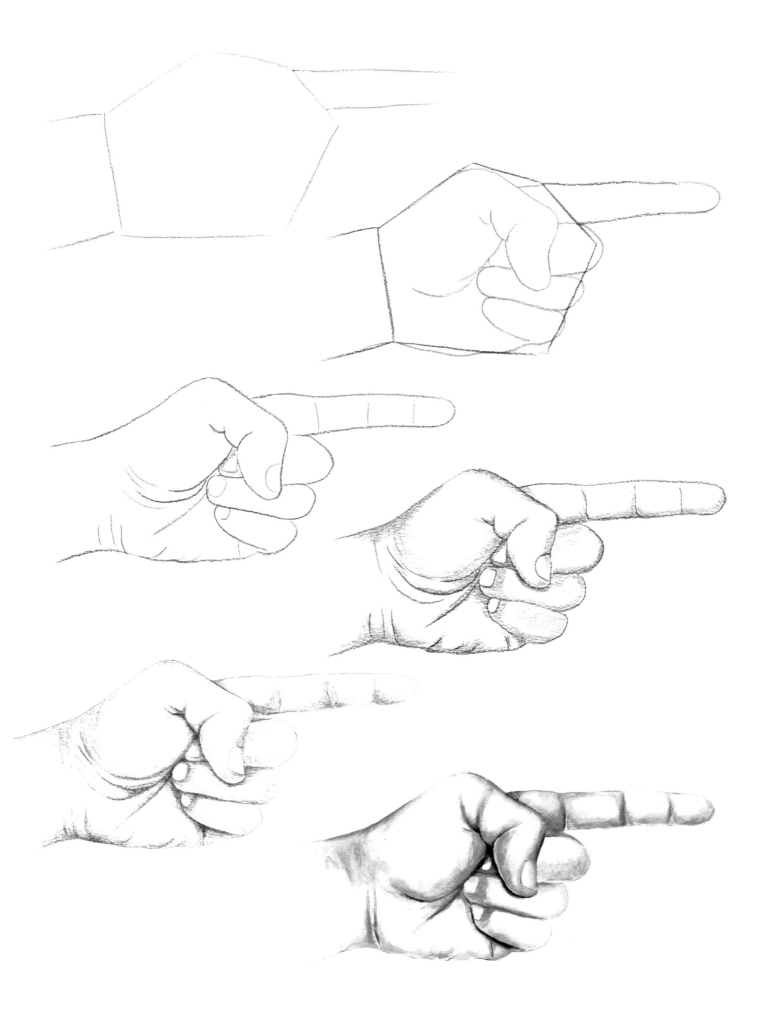

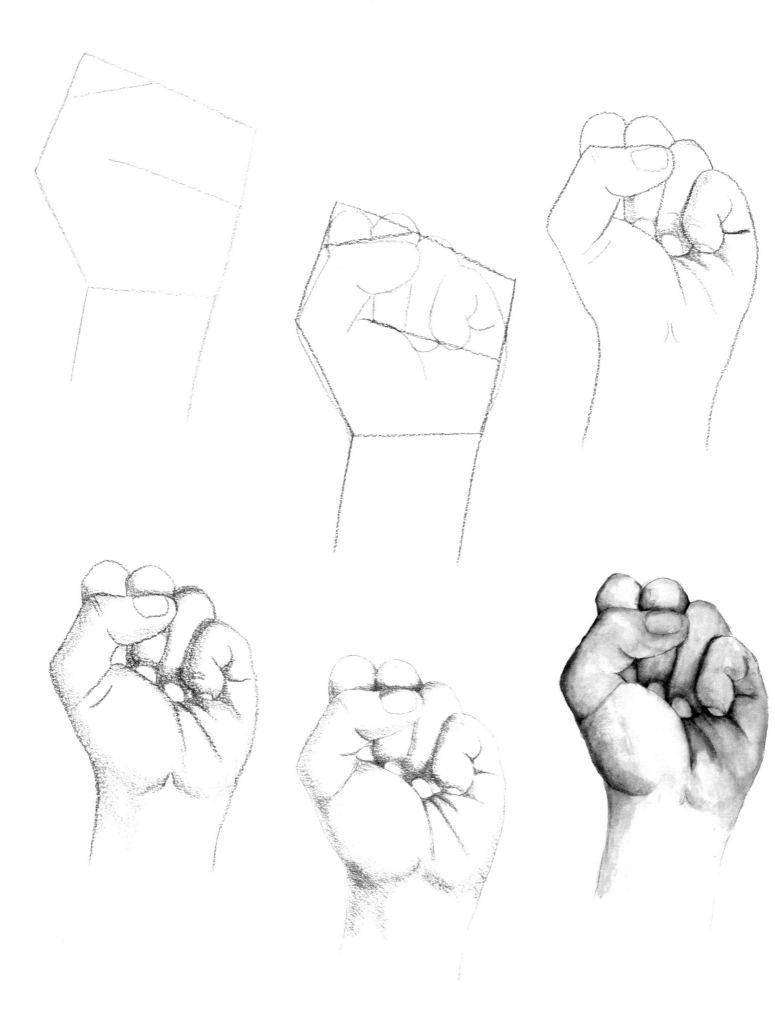

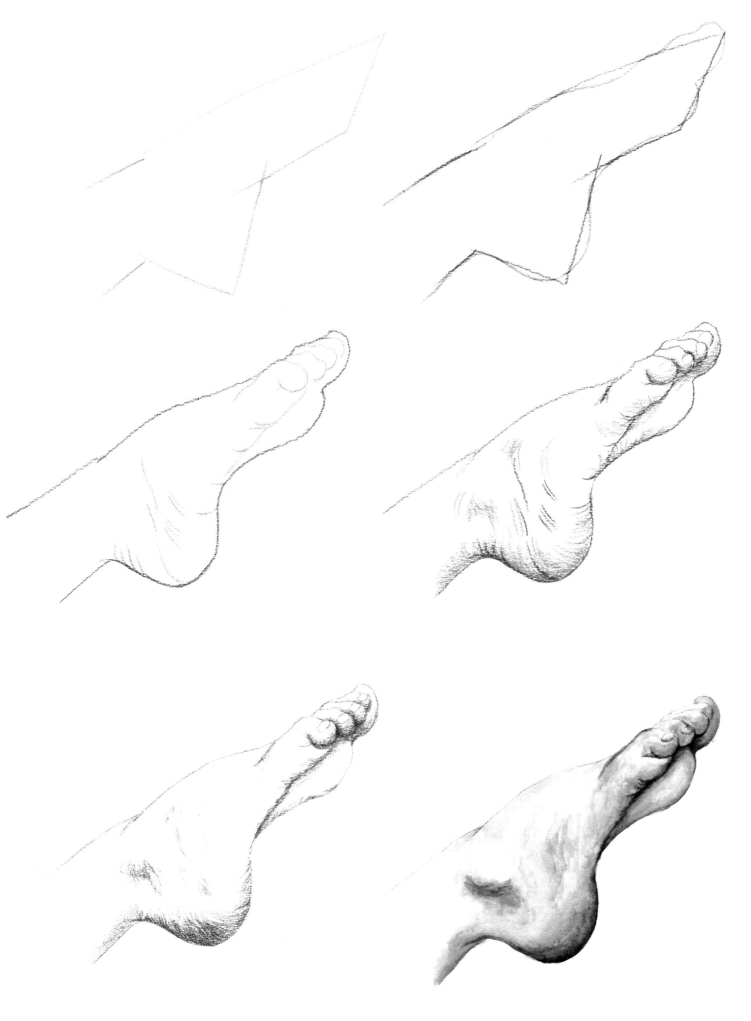

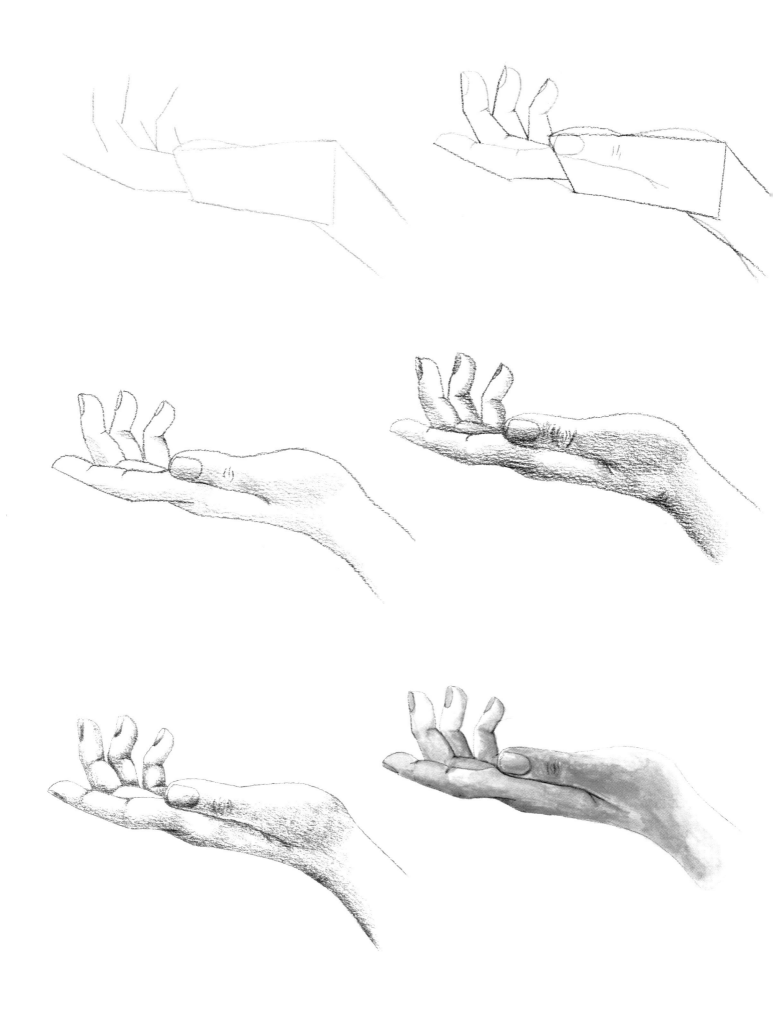

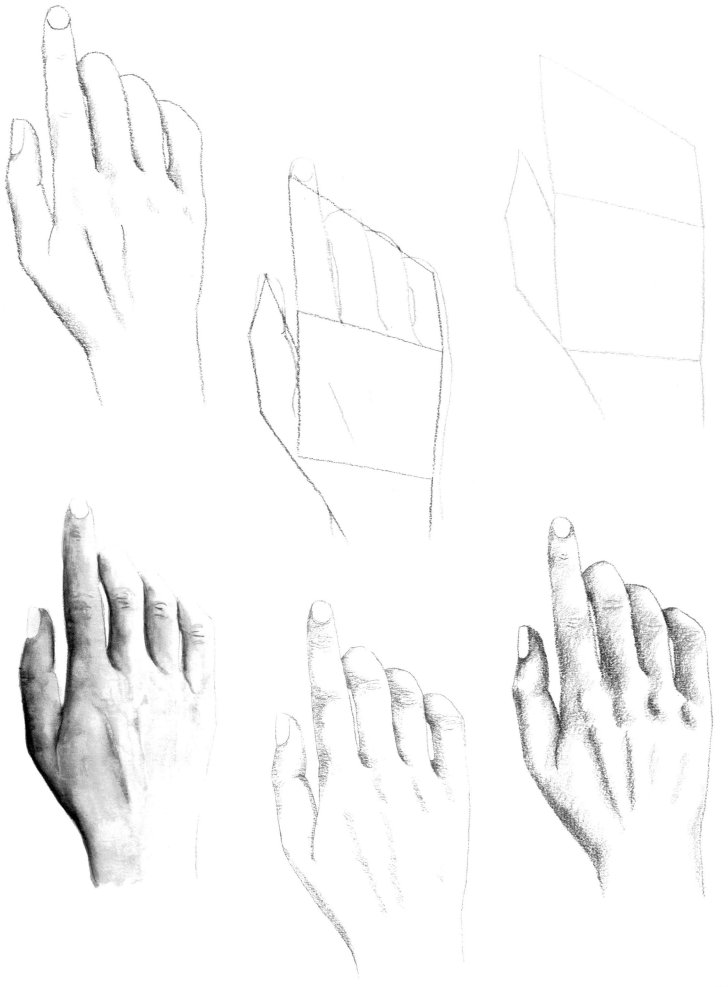

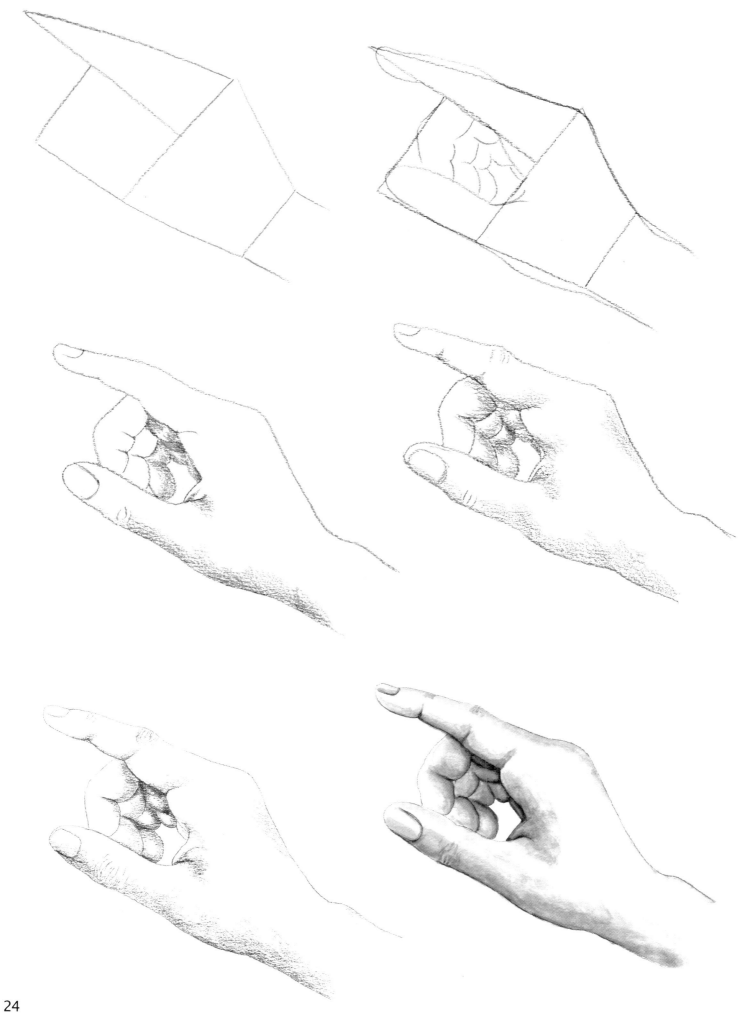

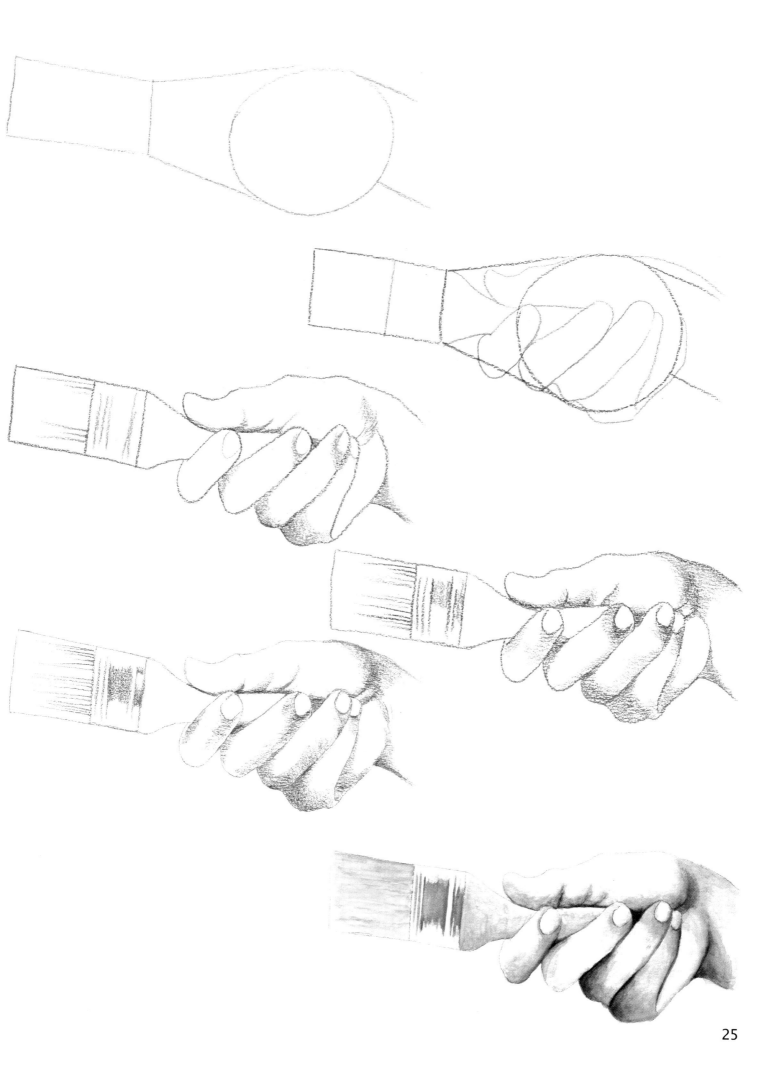

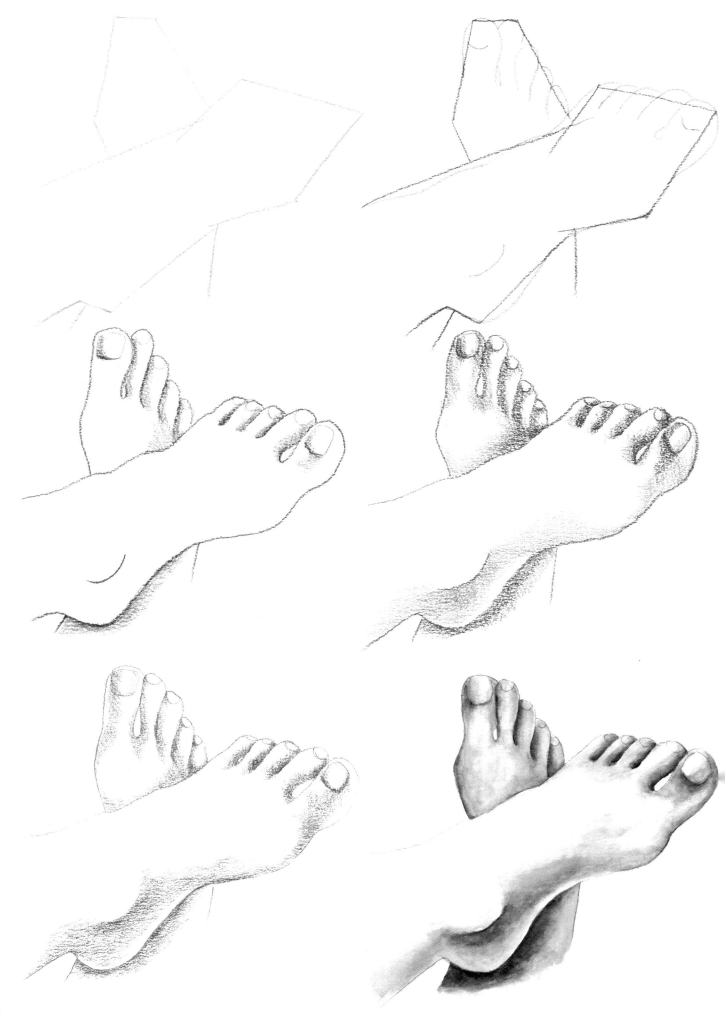

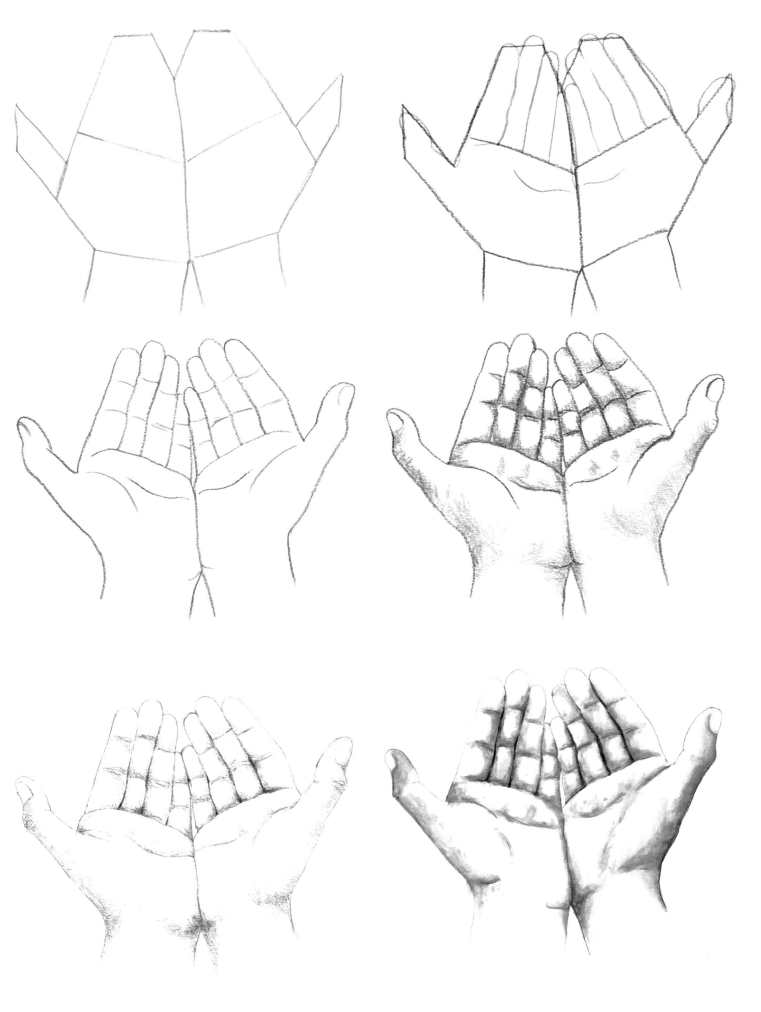

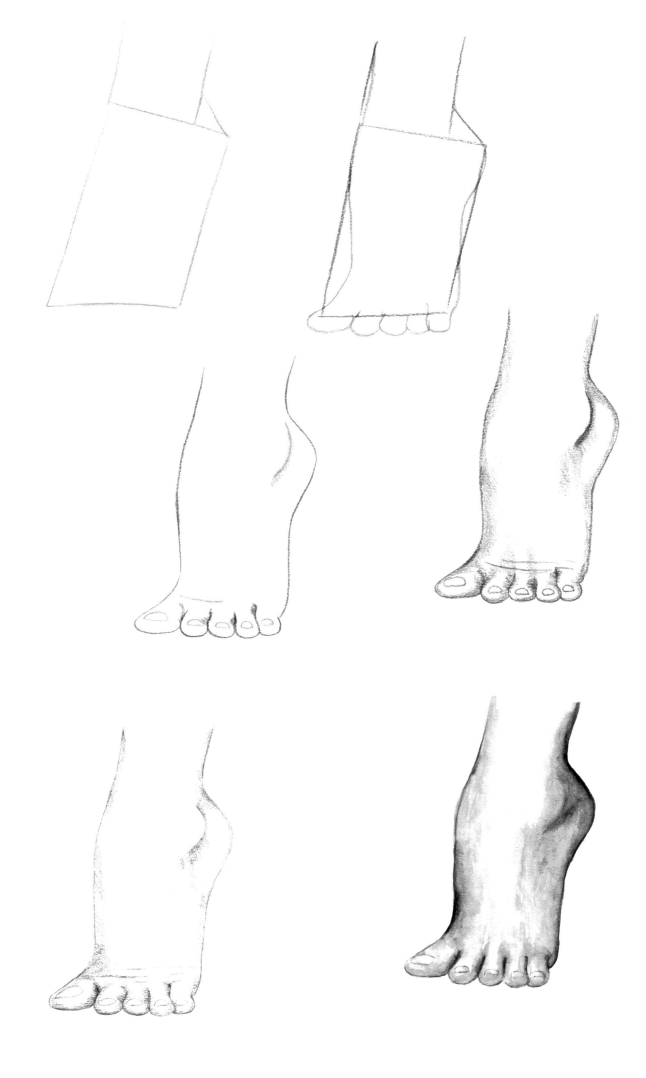

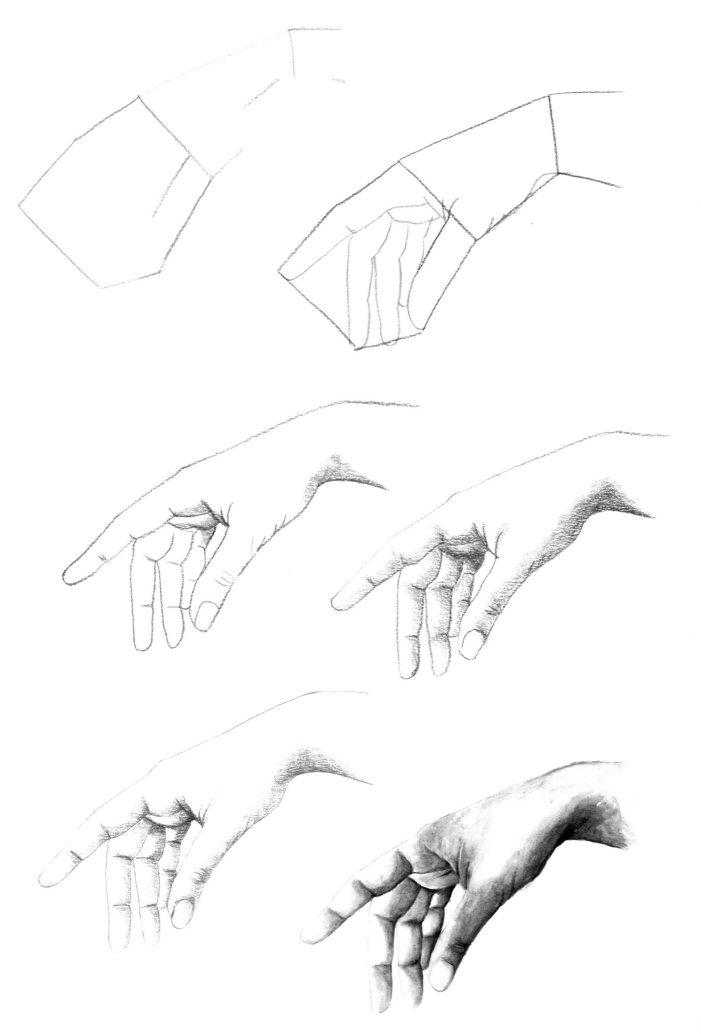

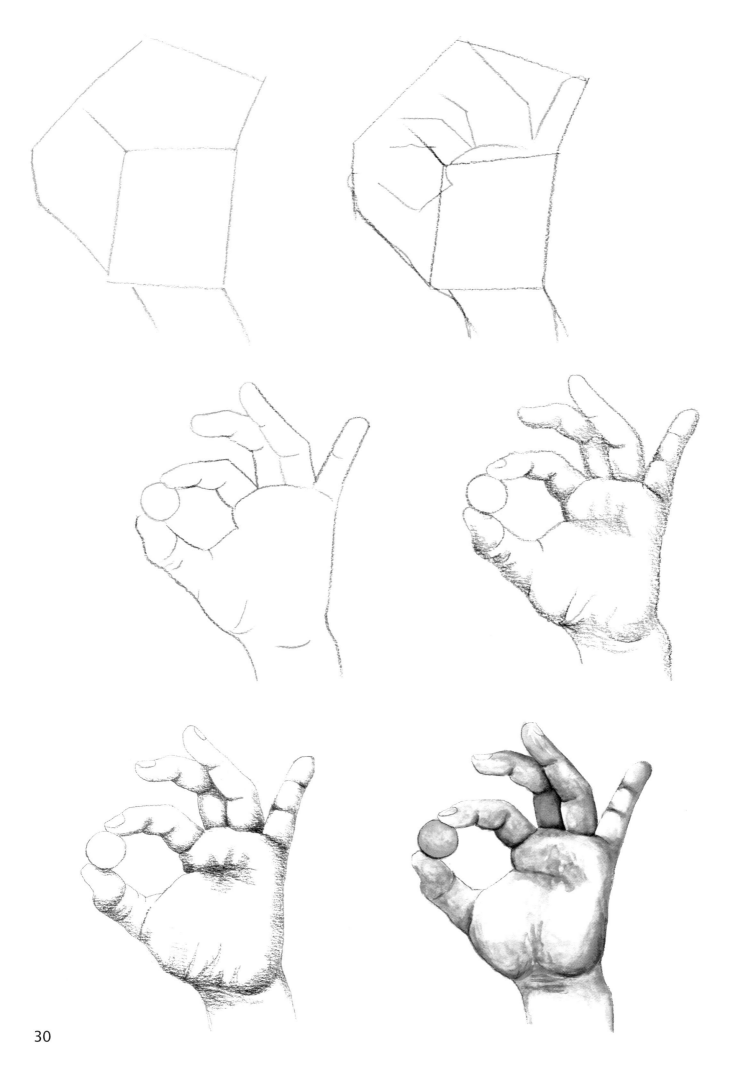

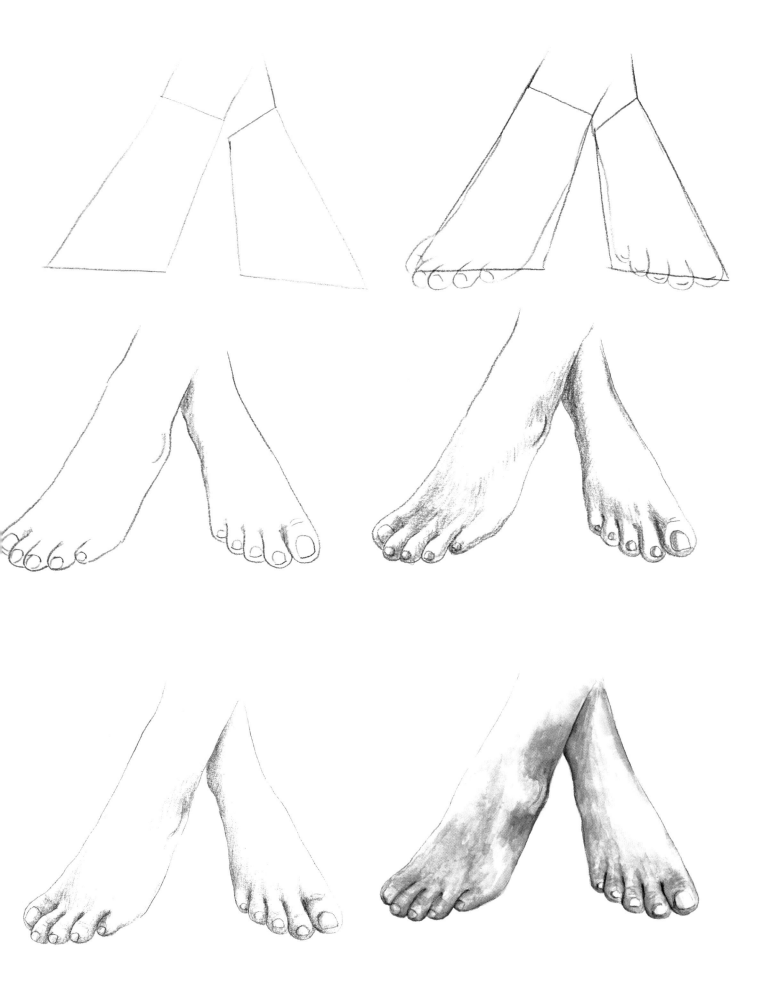

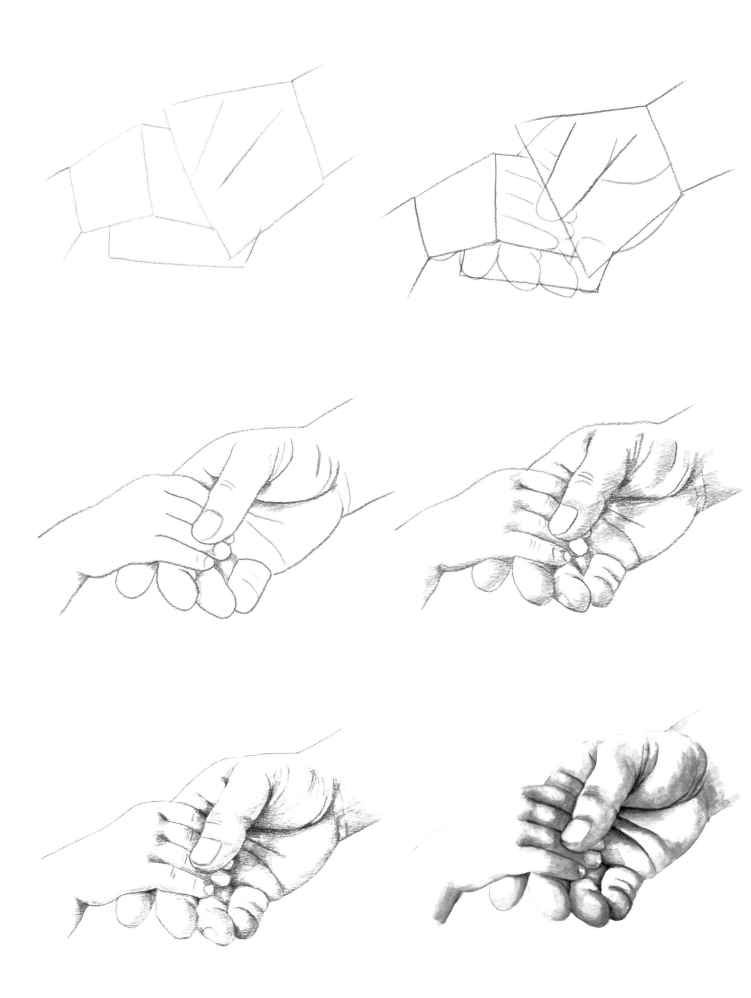